OPTIKS

Z E K E B E R M A N

BY DEBRA HEIMERDINGER

WITH AN AFTERWORD BY ANDY GRUNDBERG

UNTITLED 53

THE FRIENDS OF PHOTOGRAPHY

SAN FRANCISCO

ACKNOWLEDGEMENTS

Published in conjunction with the exhibition
"Optiks: Zeke Berman," at the Ansel Adams
Center, San Francisco, organized by
The Friends of Photography.
December 11, 1991-March 8, 1992.

All the works in the exhibition and reproduced
here are gelatin silver prints courtesy of the
artist and Lieberman & Saul Gallery, New York.

ISSN 0163-7916; ISBN 0-933286-59-7
Library of Congress Catalog No. 91-75554

UNTITLED 53

This is the fifty-third in a series of publications on
photography by The Friends of Photography.
Previous issues are still available.
For a list of these titles, write to:
Publications Sales, The Friends of Photography,
Ansel Adams Center, 250 Fourth Street,
San Francisco, California 94103.

This publication and the exhibition it documents were conceived by Debra Heimerdinger, whose enthusiasm for Zeke Berman's work is matched by her skill in analyzing and elucidating its messages. David Featherstone, director of publications of The Friends at the time the book was conceived, guided the project in its early stages. Pentagram Design Inc. generously agreed to contribute its services to the book and coordinated the design and production with grace and dispatch. The publication's designers, Linda Hinrichs and Carol Kramer of Pentagram, worked assiduously and successfully to insure that the spirit of Berman's photographs would be enhanced by the book.

The artist's representative, Lieberman & Saul Gallery of New York, was unstinting in its assistance throughout the course of the project; Julie Saul's personal interest in the publication is especially appreciated. To all these contributors, and above all to Zeke Berman, whose photographs inspired so much selfless collaboration, our sincere thanks.

Many of these photographs were made with the assistance of fellowships from the John Simon Guggenheim Memorial Foundation, the National Endowment for the Arts and the New York Foundation for the Arts. Also, Zeke Berman would like to express his special gratitude to the MacDowell Colony, Peterborough, N.H., and Yaddo, Saratoga Springs, N.Y., where many of the photographs were made.

Andy Grundberg
Director of Programs

YOU DO NOT EVEN HAVE TO LEAVE YOUR ROOM.

REMAIN SITTING AT YOUR TABLE AND LISTEN.

DO NOT EVEN LISTEN, SIMPLY WAIT.

DO NOT EVEN WAIT, BE STILL AND SOLITARY.

THE WORLD WILL FREELY OFFER ITSELF TO YOU UNMASKED,

IT HAS NO CHOICE.

IT WILL ROLL IN ECSTASY AT YOUR FEET.

FRANZ KAFKA

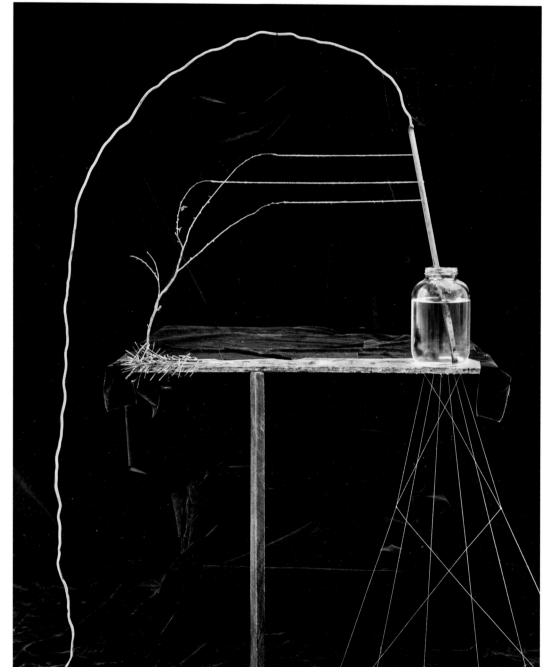

UNTITLED

1987

35 x 28½ IN.

PLATE

1

The making of visual art is governed as much by the laws of nature as by the imagination. Zeke Berman is unusually perceptive in his understanding of this interrelationship between the physical world and the world of the mind. He recognizes that both aesthetic and scientific discoveries are predicated on revealing otherwise hidden patterns of human experience. His interest in representing abstract ideas and theories informs his creative process and is a primary aspect of his art.

Trained as a studio artist, Berman is open to a variety of approaches to creative expression. His background as a sculptor has grounded him in the physicality of three-dimensional materials. His studio experience has encouraged process and invention rather than a commitment to the "decisive moment." As a result, his photographs are not easily categorized in terms of traditional photographic genres. He is a conceptual artist using photography as a complex mode of creative visual expression.

Berman's photographs are not still-lifes; they employ objects, but they are about ideas made perceivable through representation. Because he is exploring a world of visual invention influenced more by scientific theory and revelation than by any narrative ideas, his challenge is to use subject matter in ways that purposely reduce familiar associations. Ordinary materials like wood, water, clay, paper and glass lend themselves to non-narrative contexts. Their ordinariness makes them neutral enough to function as elements in a world of rich and often paradoxical visual ideas.

OPTIKS

By Debra Heimerdinger

OPTICS AND PERCEPTION

Optics is a branch of physics that studies the nature and properties of light and vision. It can be studied at several highly scientific levels including geometrical optics, physical optics and the design of lenses. But when Berman uses the word, he uses it in a simple way to indicate a sophisticated system—that is, "You have a subject, you use a lens, you make an image. This is an obvious and powerful schema for a procedure that generates images."[1] Historically, this system was the basis of the camera obscura. Used in the late sixteenth century as an aid to drawing, this device was developed over the next two centuries to incorporate increasingly refined lenses. This "system" of optics and images paved the way for the invention of photography, which Alfred Stieglitz once described as the bastard child of art and science.[2]

While optics provides the impetus for Berman's images, theories of perception guide their fabrication. Historically a branch of optics, perception has always been chameleon-like. From Plato's time until the seventeenth century, visual perception was understood as the apprehension of the physical world through rays emitted from the eyes rather than the eyes' and brain's reception of images through light striking the surfaces of objects. In contemporary inquiry its meaning changes according to its applications in psychology, physiology and philosophy. Perception is viewed by some who study it as more innate than empirical, implying that "seeing" ultimately is based on unconscious sensory data stored in the memory.

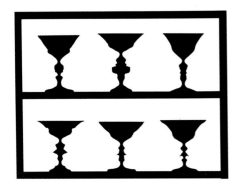

GOBLET PORTRAITS (DETAIL)
1978
12 x 15 3/4 IN.

Optics and perception theory are the primary intellectual supports of Berman's work. The perceptual progression from "object" to "image" to "idea" is at the core of what his pictures are about. When perception theory is applied to Berman's subject-lens-image system, it suggests the differences between the world as it appears in front of the camera lens and the image ultimately projected on the other side. One can imagine the artist working in his studio. Over an extended period of time, he painstakingly arranges light and objects on one side of the lens; the film in the camera reads what the eye sees; in the artist's mind are ideas and theories that inform his ultimate perception and realization. The process is a continuum along the axis of subject, camera and artist. It speaks of ongoing production. The photographs are a progression of images and ideas, each one related to the next. "I attempt to make photographs that deepen my understanding of how we see, how we apprehend the world with our eyes," Berman says. "Our experience of the world is totally mediated by our senses. The only way we can understand the world directly is through our senses, and they, of course, are subjective."

Berman reads widely and draws on many sources and ideas for his work. In the area of subjectivity and perception he has been particularly interested in Warren J. Wittereich's experimentation based on the Ames room, a full-scale, distorted room devised by the psychologist Adelbert Ames for his seminal studies of the relationship between the perceiver and the perceived. Focusing on the subjectivity of perception, Wittereich declared it to be "an ongoing process that involves our image of our own self, our needs, values and purposes, as fully as it involves the image of the object perceived." In experiments conducted in the 1950s at Princeton and the Naval Medical Research Institute in Bethesda, Maryland, Wittereich documented that emotions influence perception. He concluded that "experiments with specially distorted rooms reveal that the way in which we perceive size and even shape of others is powerfully influenced by our emotional relationship with them....This suggests that the world each of us knows is a world created in large measure from our experience in dealing with the environment."[3]

In his photographs Berman establishes situations that create a discomforting duality in which one is split between seeing and not seeing. "I like to slow up the process so that the viewer will notice himself recognizing what's happening," he says. The resulting state of conflict raises the viewer's level of anxiety and heightens the process of perceiving. This aspect of Berman's work corresponds to the belief that photographs by their nature contain a perplexing duality. They can be seen as containing readable objects in an implied three-dimensional space, and they also can be read as non-objective patterns of lines and shapes on a flat plane. As patterns they suggest two dimensions; as objects the effect is three-dimensional. And yet no object can be two-dimensional and three-dimensional simultaneously.

As a result, photographs contain paradoxical information. They challenge visual interpretation and create perceptual dilemmas. Berman capitalizes on this situation. The paradoxical

arrangements of objects and disorienting optical illusions in his photographs demand complex responses that require looking and thinking. Berman builds into his photographs a perceptual architecture that gives the viewer a space in which to interpret and reinterpret what is perceived.

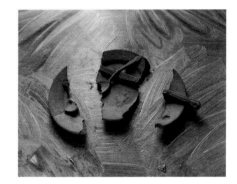

SNAP
1982
15½ x 19½ IN.

STRUCTURE, ORDER AND FORM

Three elements that are strongly linked in Berman's work are structure, order and form. In *Entropy and Art*, Rudolf Arnheim writes specifically on the subject of structure in works of art. He states:

The structural theme must be conceived dynamically, as a pattern of forces, not an arrangement of static shapes. These forces are made visible…This complex theme of forces is readable by virtue of the delicate visual balancing of sizes, distances, directions, curvatures, volumes. Each element has its appropriate form in relation to all the others, thus establishing a definitive order in which all component forces hold one another in such a way that none of them can press for any change of the interrelation.[4]

The portrayal of a pattern of "forces made visible" is intrinsic to Berman's work. He characteristically achieves this by selecting and shaping materials to refer to the order of the natural world. *Untitled, 1987* [plate 1], for example, explores the concepts of dynamic balance and maximum play of force. In this picture an armature of wire rises from the base of the photograph's frame and arcs into a partially filled jar of water resting on a table top. At the spot where the jar sits, the table appears to be supported by a geometric cat's cradle of string, which completes an inventive loop of familiar elements and inexplicable interrelationships. It is an image of force, tension and paradox, suggesting both the physiological structure of vision and the poetic idea of vision as a force of the imagination.

ENCLOSURE, COMPLETION AND GESTALT

The gestalt idea of closure—the mind's completion of what the eye receives—underlies much of Berman's work. Gestalt psychology affirms that the nature of parts is determined by and is secondary to the whole. Because experience is a response to integrated structures and patterns, the mind constantly completes the sensory input that the eye sends to the brain. For example, an object represented photographically on paper gives us incomplete physical information. In this two-dimensional representation only certain views will be visible—the third dimension is missing. The mind routinely completes the picture by reconciling what it remembers seeing in the past with what it sees in the present.

Berman's interest in gestalt theory led him to the use of clay as both subject and material. In describing *Snap, 1982,* Berman said, "I was working with the concept of the gestalt. Closure is one of the things we experience when we look at objects, and we complete the backs of them and also the insides. I wanted to make a false object cast in clay and snap it open to show—to see—that this object isn't real. It's only clay."

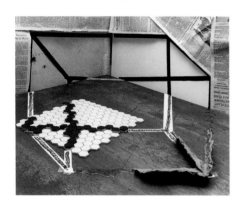

STILL LIFE WITH NECKER CUBE
1979
15½ x 19½ IN.

Clay has had a special appeal for Berman. It is malleable and accepts impressions. With it the artist can shape his material and leave a personal mark. Most of all, it is a vehicle for the artist's hand. Berman's physical involvement with the constructions that he transforms into photographs extends beyond clay to all the materials he uses. This physicality is in counterpoint to the theoretical aspect of the work. In effect, Berman proceeds from a base of sophisticated ideas, then clarifies and simplifies them as constructions by manipulating his materials in a direct, physical way. Like a sculptor who sometimes must "feel" rather than "see" a work inside a block of stone or clay, Berman touches, moves and shapes materials to create the final piece. The presence of the artist is distinctly felt in the objects in his photographs. Like the enigmatic boxes of Joseph Cornell, Berman's photographs are "made" works.

The idea of the photographer as maker or author of his or her work has only recently come into prominence. The scene was set for a major divergence from photography's dominant reportorial mode in the late 1960s and 1970s. John Baldessari, Robert Cumming, Ed Ruscha and Lucas Samaras, along with other painters, sculptors and performance artists whose photographs were fueled by concepts, ideas and invention, helped blur the distinction between "artist" and "photographer." Their work influenced younger photographers and paved the way for a proliferation of non-reportorial photography that took place in the late seventies and eighties and continues in the 1990s.

Artists working in this vein today use a variety of approaches to express diverse concerns about politics, art, history, science, religion, gender, psychology and media. What they have in common is an emphasis on the artist as author of the work, a commitment to conceptual modes of art making and an often theatrical use of space. These qualities characterize the work of such artists as Cindy Sherman, Victor Burgin, David Hockney, Barbara Kruger, Laurie Simmons, Frank Majore, Jo Ann Callis, James Casebere, Barbara Kasten, Sandy Skoglund and William Wegman.

Like Berman, some of these artists—particularly Casebere, Callis and Kasten—have worked sculpturally with generic materials. But Berman's idea-based sculptural constructions, laced with wit and irony, seem closer to Robert Cumming's photographs of the seventies. Like Cumming, Berman integrates common materials with perceptual ideas. Their work avoids logical narrative; the recognition and relationships of objects are blurred and provisional, and the familiar is replaced with illusion.

STRATEGIES AND DEVICES

Berman's desire to use objects and materials relationally rather than symbolically is a constant in his work, evident from his early photographs of the late seventies to his most recent. But while this intention has remained constant, its expression has evolved as the artist has explored concepts of optical illusion, paradox, dimensionality, closure and duality.

In *Goblet Portraits,* an early piece, Berman expressed his fascination with duality and optical illusion by photographically re-creating a classic perceptual conundrum. Looking at *Goblet Portraits* requires the viewer to switch between meanings. Depending on individual perception, one first sees either faces in profile or the silhouettes of stemmed cups. This piece hints of things to come in Berman's work, anticipating his exploration of three-dimensional space on a two-dimensional plane.

When he began to photograph seriously in the late seventies, Berman drew on his background as a sculptor for the content of his photographs. The photographs, however, have never been intended to be seen as records of three-dimensional arrangements that the artist has made. Berman sees the pieces he constructs as provisional; they are a part of the process of making the photograph, which is his ultimate end.

I originally made sculpture but have become attracted to placing a camera between myself and what I make. The result is a kind of distancing that transforms the physical construction into an optical one. Because photographs look so real, have such an apparent fidelity to their subjects, photography has been for me a rich medium in which to test the provisional nature of both pictorial representation and visual experience. I've grown to think that photographs are sturdier than sculpture. Because they are so thin, have such physical economy and are made exclusively for our visual contact, they take on a kind of immutability.

The paradox implied in the optical illusion of *Goblet Portraits* became more central to Berman's work in 1979. In pieces from that year like *Measuring Cup, Cubes* and *Still Life with Necker Cube*, optical illusion was combined with an expanded vocabulary of materials to explore the concept of closure directly.

In *Measuring Cup,* a web-like tracing of water on a table becomes a background for a glass cup filled with water—a double enclosure. In *Cubes,* newspaper pages outline a pentagon shape on the floor, mirroring the solid cube of wood placed off to the side. *Still Life with Necker Cube* shows a series of geometric enclosures within enclosures, with the isometric cube of Necker, the Swiss naturalist, at the center. This was the first photograph Berman made with newspaper as an element. "I used it to make a ghost shape of the cube so that it would be more visible," he says. "It then occurred to me that newspaper has news on it and could become a way to allude to what's happening in the world at the time the picture was made."

In subsequent pieces the concept of enclosure is expressed more tenuously. It becomes plastic and web-like through the use of slender wire, string, rope, branches and filaments from a hot-glue gun used in carpentry. The effect is less emphatic and more subtle, and there is a shift from enclosure to connection. The thread-like elements such as string and hot glue relate specifically to ideas in perception theory about eye motion and visual recognition. Berman uses glue and string to represent line patterns that "indicate how the eyes might scan the image in order to recognize it."

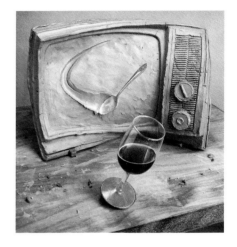

FALLING GLASS
1983
16½ X 15½ IN.

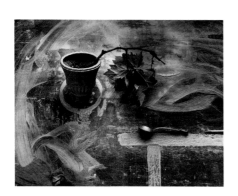

In his photographs of the early eighties there is an emphasis on edges, which are employed both conceptually and aesthetically. The concept of the edge is represented by the tabletop. Its technical complement in photography is edge lighting, a lighting method that emphasizes linear materials such as string and branches.

In the mid-eighties, Berman began to use black velvet as a background to further emphasize the edges of objects. As a backdrop it accommodates edge lighting and pushes his three-dimensional arrangements to the foreground. The emotional impact of the dark drape and its suggestion of substance is appealing to Berman. The drape also has the effect of enveloping the constructions, echoing in another way Berman's concern with enclosure and containment.

The velvet backdrop also echoes seventeenth century Dutch still-life painting. In many of these paintings backgrounds are equally dark. Tables, employed extensively as the staging area, often are draped with velvet. Arrangements of fruit, flowers, food, glassware and other objects dominate the foreground of the canvases. But in contrast to the opulent subject matter of these paintings, Berman's materials are spartan and plain. The paintings, with their partially peeled fruit, joints of meat and extravagant flowers, are juicy with life and immediately familiar. Berman's photographs, however, seem to exist in the form of an unknown language. To Berman the table edge "suggests a different compositional strategy—a structural strategy. A strong sensation of gravity can be evoked by composing the picture around rectangular shapes which line themselves up to the frame of the picture. It creates a compositional hierarchy where things are stacked from the bottom to the top."

The tabletop began to appear as a device in Berman's work in pictures like *Falling Glass, 1983* and *Table Study, 1983*. In these two pictures the table was the ground for the use of clay, a material that served as a structural device for appearing to defy the laws of gravity. In *Falling Glass* a filled wine glass is balanced in a seemingly impossible relationship to a table on which also rests a distorted but solidly represented clay TV. In *Table Study* Berman used clay as a painting medium by diluting it with water. He brushed it on the actual table surface, painting the outline of a table, the edge of which supports an "unsupportable" spoon.

The interest Berman expressed in the gestalt of *Snap* in 1982 reappears in the late eighties in a concept he calls sidedness. To him the frontality of a photograph suggests not only the reverse side but also the unseen edges of things. "I think of photography as being the art of distance because you're always at a distance from the subject. You only see things from the camera's point of view, from the front, and I was thinking of the backs of things."

In 1987, working with his concept of sidedness, Berman photographed the front and back of a paint-encrusted drawing board supported by curved, wooden chair sections that he devised as a stand. He then printed each negative, with one flipped for a mirror effect, and joined them in the diptych *S.V.A. Drawing Board, Both Sides, 1987* [plate 5]. This piece was a catalyst that led to a series of diptychs that imply mirror images. It is a perplexing picture because

it suggests a three-dimensional completeness that cannot possibly be. It contains the elements of three dimensions—the front and back of the drawing board—but they are shown as linear; there is no dimensional space represented. The photograph contains the components of three dimensions but not the form.

Berman's most recent work confronts the dual nature of the photograph as simultaneously abstract and representational. He considers abstraction in photographs as "an interesting but contradictory idea." On an optical level, however, he looks upon the lens as an "abstractor" and sets out to make photographs without objects. Pictures like *Projector, 1989* [plate 21] and *Factors, 1990* [plate 20] are made with objects purged of significant volume and functional meaning. Such images, Berman says, "are about patterns generated by and distilled from objects and devices I have previously used in photographs. For example, the tabletop and the form of a newspaper are composed of shapes that incorporate rectangles, diagonals, horizontals and verticals. They are composed of angle and line. There is a geometry in these pictures that creates a certain logic." In these photographs Berman is using optics as a medium; the photographs are equivalents for his ideas.

Like photography itself, Berman's work is governed by the dimensional duality of pictorial representation. His images encompass aspects of paradox, illusion, perception, fidelity, ambiguity and the navigable territory between representation and abstraction. These are elements that are basic both to the medium he has chosen to use and to his creative exploration of perception, in which he strives to transform physical realities into abstract ideas.

NOTES

[1] This and following quotations by Zeke Berman are excerpted from a lecture given at a workshop sponsored by The Friends of Photography in July 1990.

[2] Alfred Stieglitz, "Pictorial Photography," *Scribner's* 26 (1899), 528. Cited by Sarah Greenough, "The Curious Contagion of the Camera, 1880-1918," *On the Art of Fixing a Shadow* (Bullfinch/Little Brown and Company: Boston), 145.

[3] Warren J. Wittereich, "Visual Perception and Personality," *Scientific American*, April 1956, 55-60.

[4] Rudolf Arnheim, *Entropy and Art: An Essay on Disorder and Order* (Berkeley: University of California Press, 1971), 33.

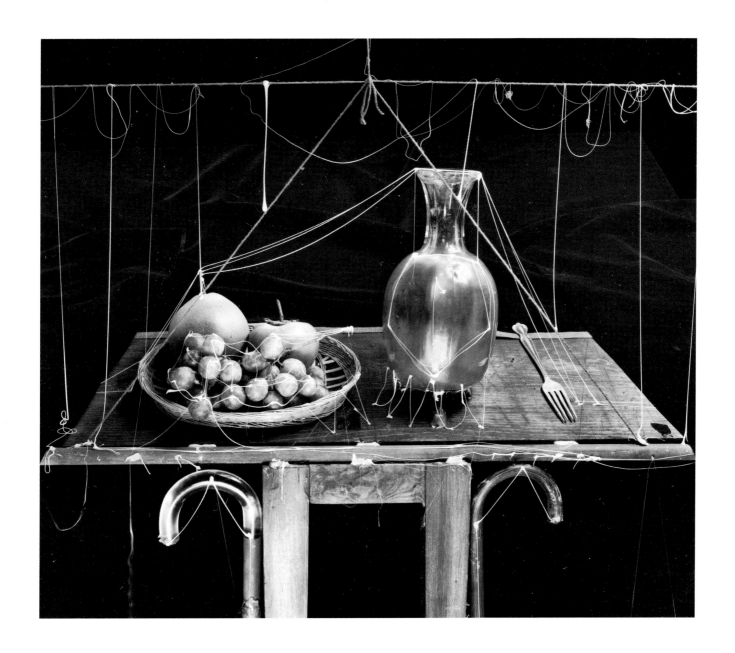

Plate

2

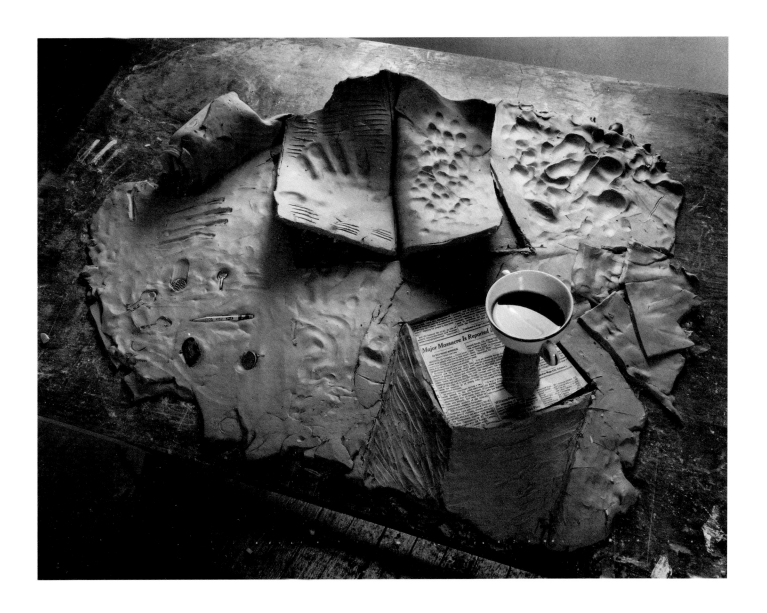

PLATE

<u>3</u>

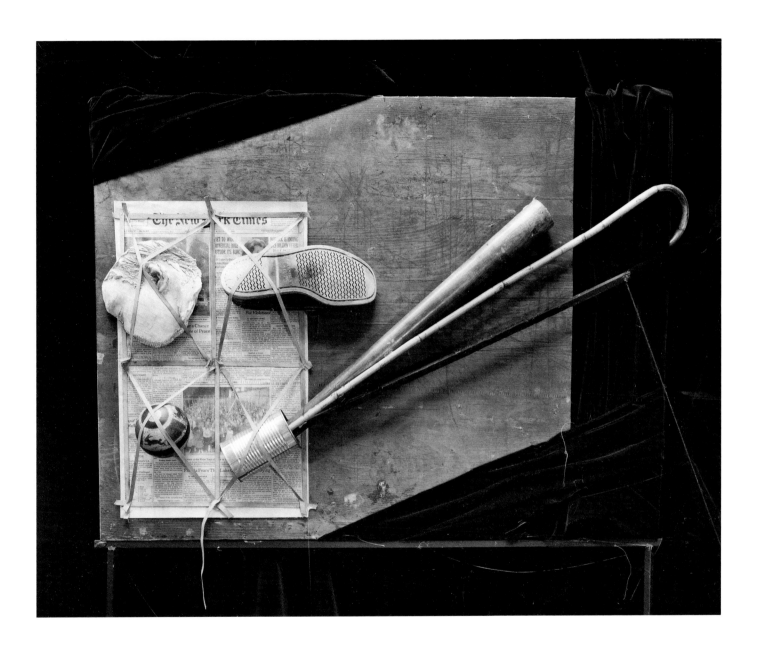

PLATE

4

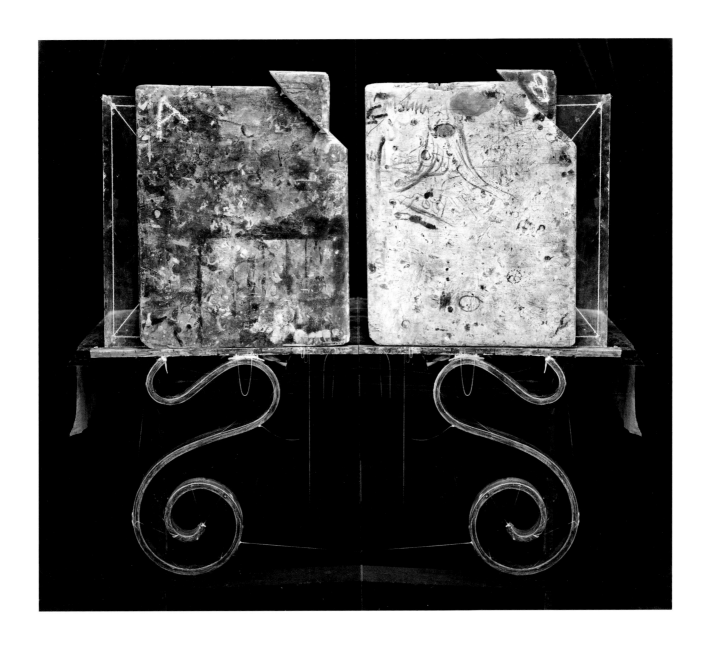

Plate

5

Untitled

1986

38 x 19 in.

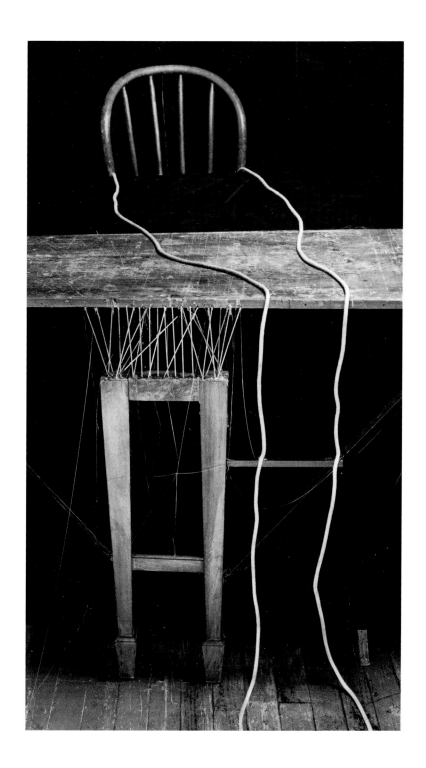

PLATE

<u>6</u>

<u>Untitled</u>

1986

38 x 26 in.

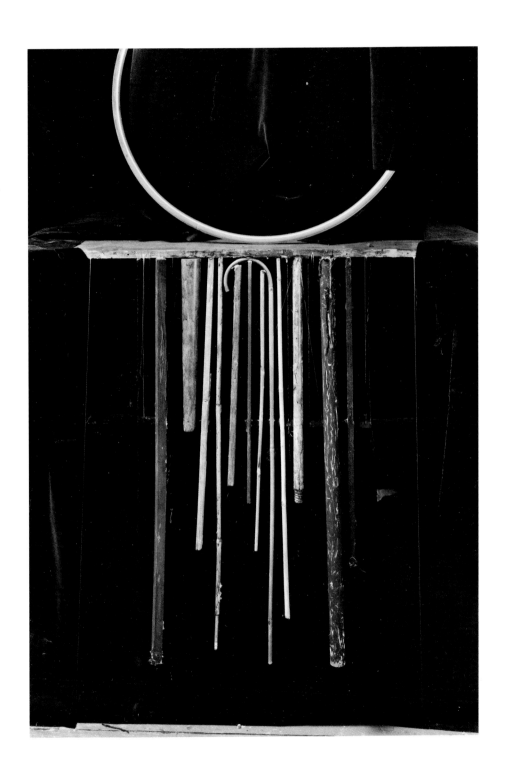

Plate

7

UNTITLED

1986

38 x 26 IN.

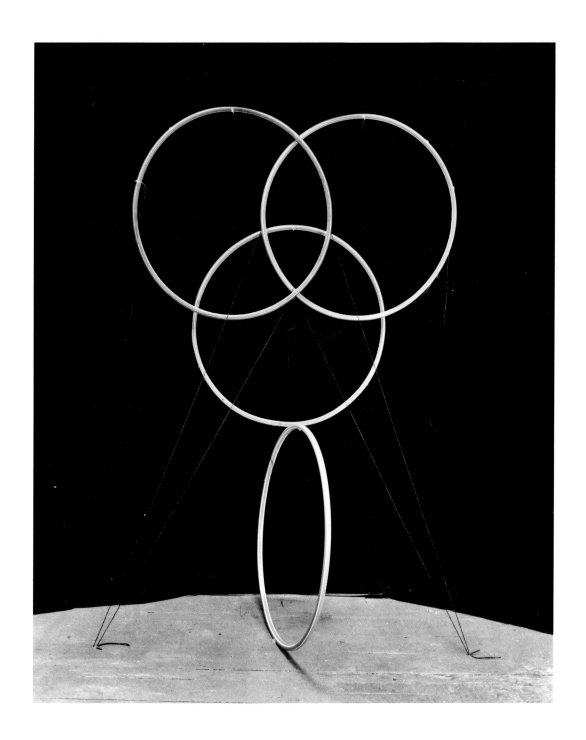

PLATE

<u>8</u>

Untitled

1986

15½ x 19½ in.

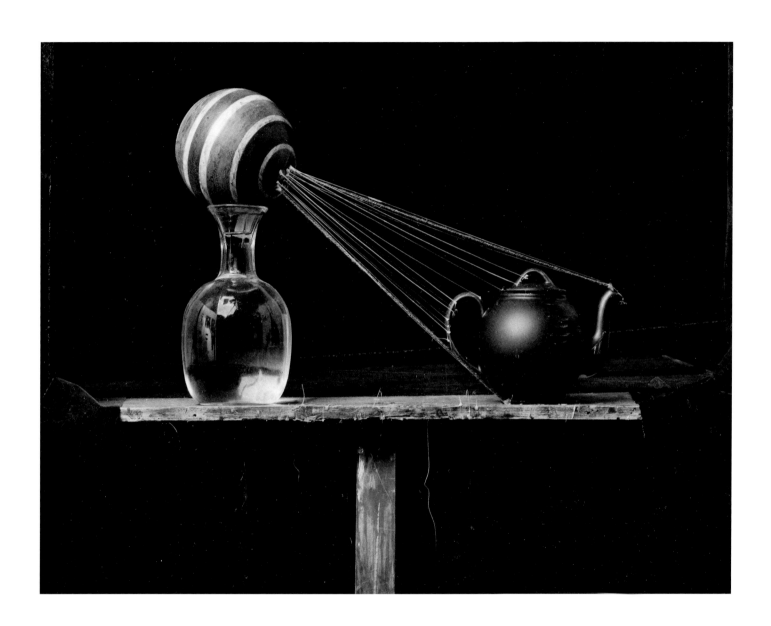

PLATE

9

<u>Tapping</u>

1988

Diptych

19 x 19½ in.

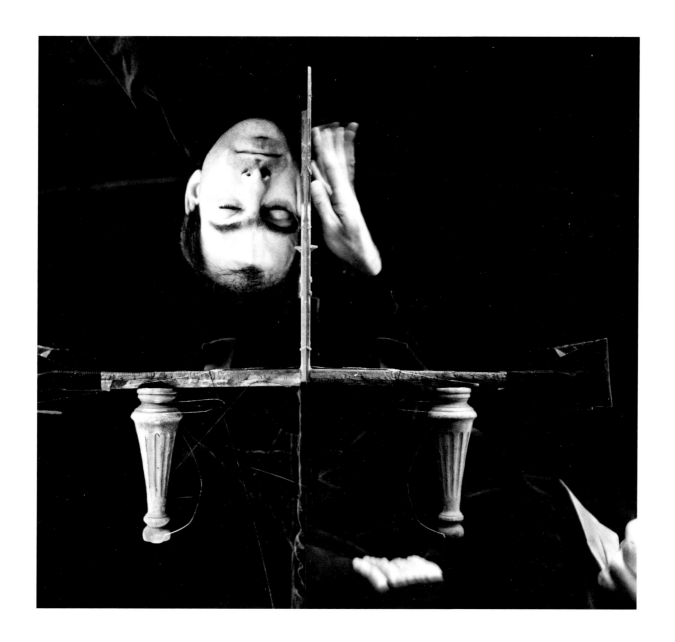

PLATE
10

MAY 20TH

1989

DIPTYCH

26 x 39 IN.

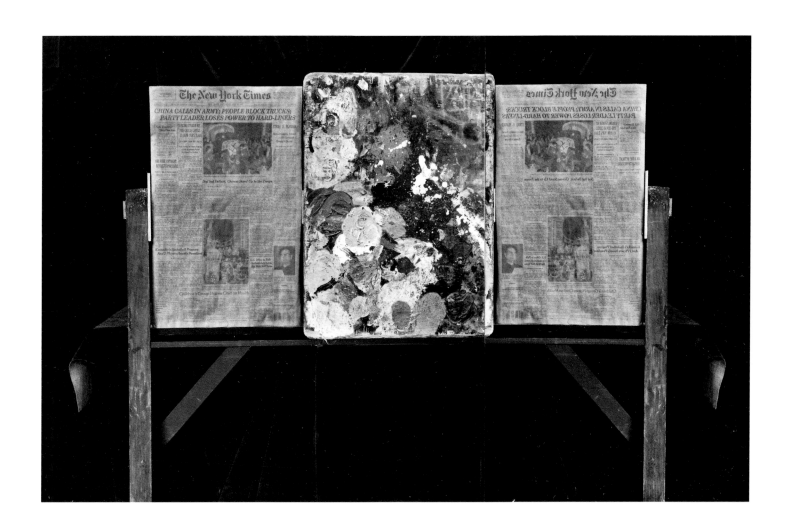

Plate

11

UNTITLED

1988

26 x 32 IN.

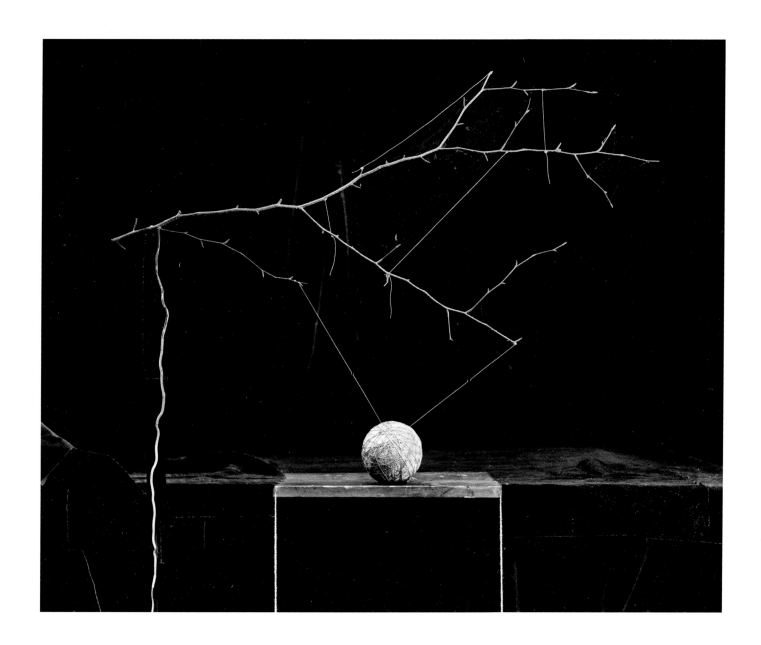

Plate

12

KITE
1985
27 x 36½ IN.

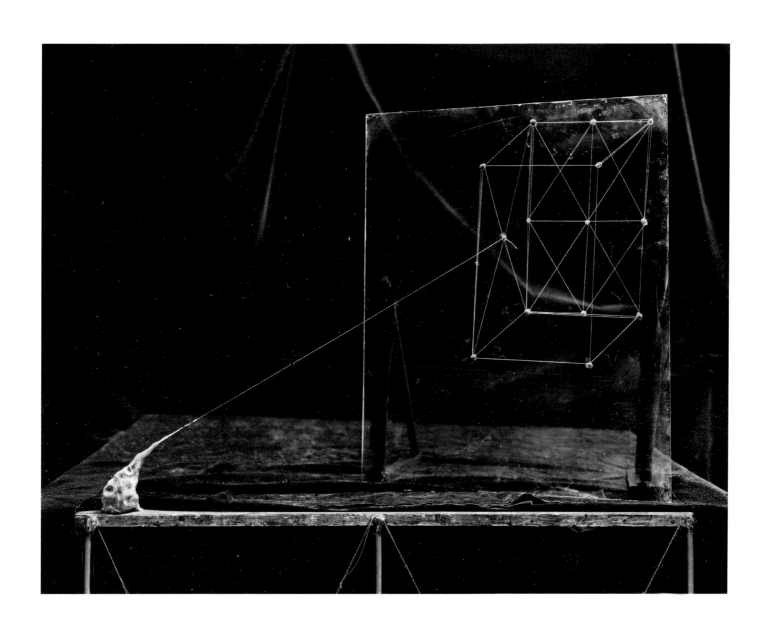

Plate
13

<u>Untitled</u>

1989

32 x 30 in.

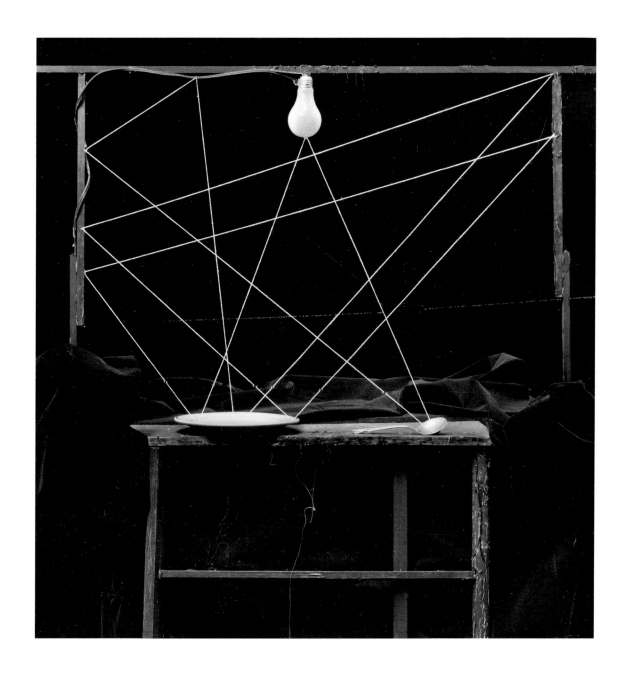

PLATE
14

<u>Untitled</u>

1989

32½ x 25 in.

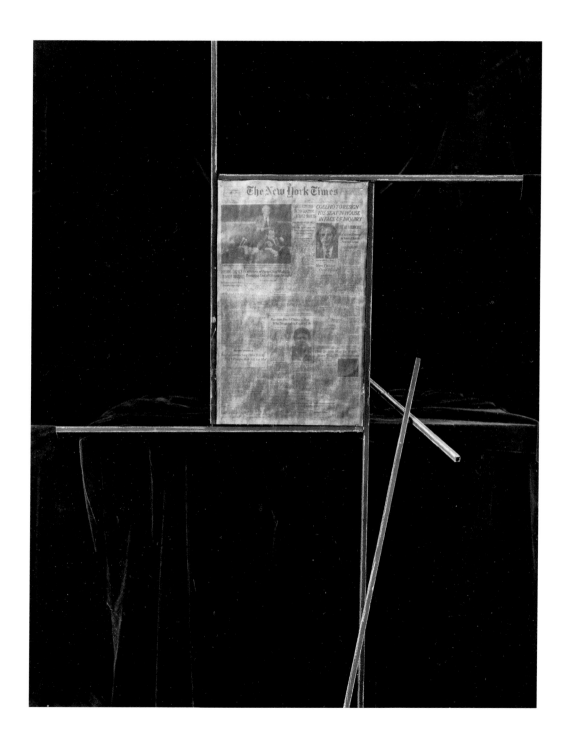

PLATE

15

UNTITLED

1988

DIPTYCH

27 X 39 IN.

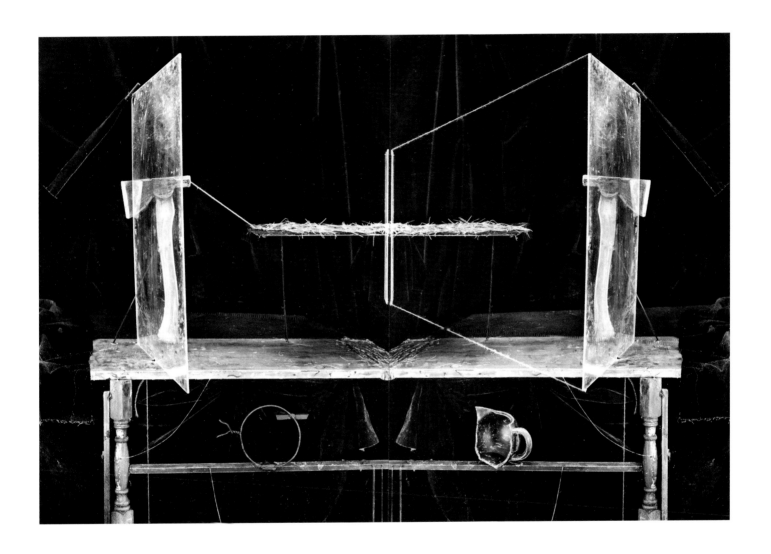

Plate

<u>16</u>

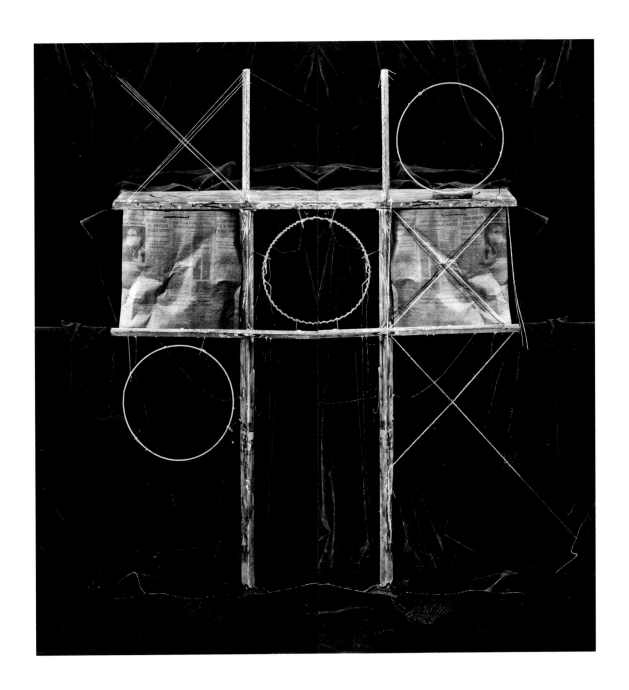

PLATE

17

JAIL

1989

DIPTYCH

23 x 34½ IN.

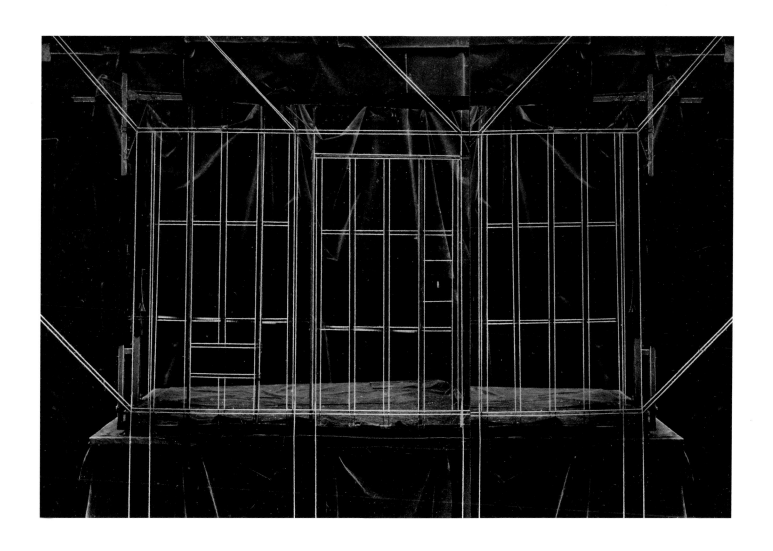

Plate

18

<u>Rack</u>

1989

DIPTYCH

22 x 32 IN.

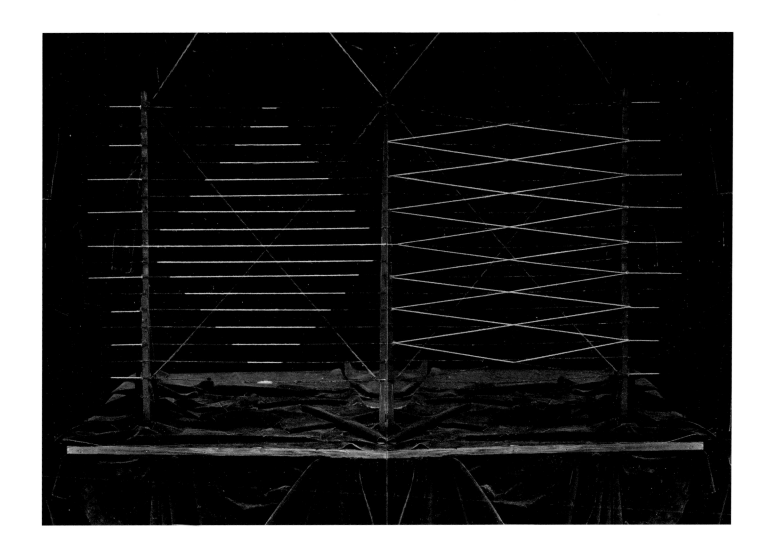

PLATE

<u>19</u>

<u>Factors</u>

1990

19 x 30½ in.

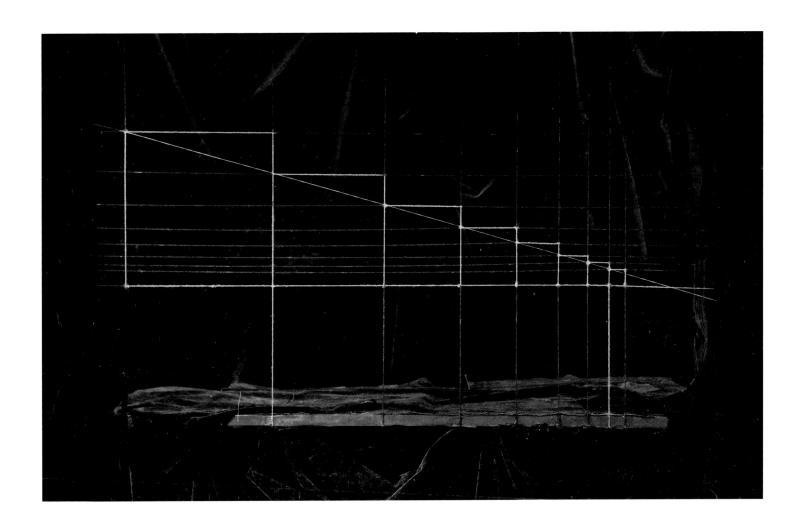

Plate
20

PROJECTOR

1989

DIPTYCH

21 X 37¼ IN.

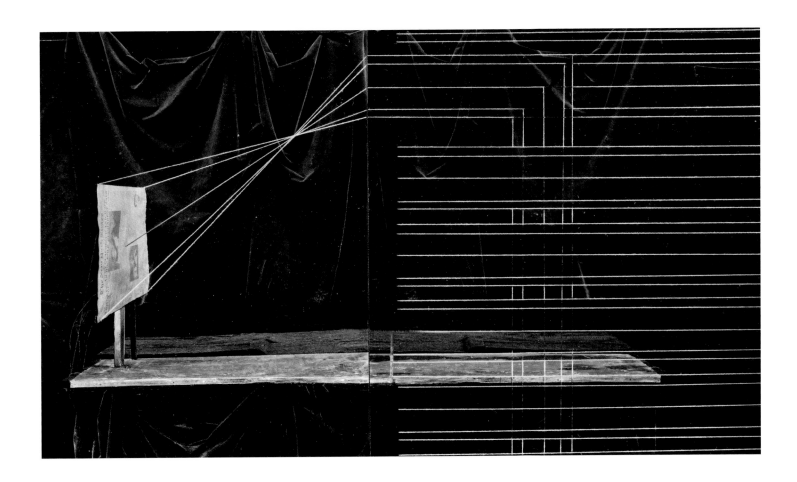

Plate

21

Zeke Berman's pictures demonstrate the potentials of what lately has come to be called the studio practice of photography. At first glance forbidding and hermetic, on close inspection they disclose a world of substantial wit and charm. Spun out like the webs of a slightly disoriented spider and filled with confounding, sometimes dizzying dimensionality, Berman's constructions turn out to be snares of a uniquely pleasurable sort.

The photographs reproduced here also testify to the importance that the medium of photography has come to assume within the larger world of art, and to the interactive practices that characterize contemporary art practice. No longer do artists and critics insist on a medium-based condition of purity, as Paul Strand, Alfred Stieglitz and Edward Weston did in the photography of some seventy years ago. The medium is no longer the message for artists like Berman; it is merely the most efficient and effective means for getting certain messages across. If the results resemble sculpture squeezed into two dimensions, or drawings of Rube Goldberg-like complexity, so much the better.

Berman's messages have to do with our most basic assumptions about visual information. His work seems to want not only to disclose the codes of conventional perspective but also to disrupt and reorient them. One is tempted to call him a deconstructionist critic of Renaissance notions of space. These notions assume, among other things, the integrity, autonomy and centrality of the viewer. Indeed, the implied dominance of the viewer in Renaissance space—as one who surveys a largely inert, submissive subject—has become the focus of recent theoretical attempts to uncover the ideologies embedded in the optical traditions of Western art.

In short, how we see is no less important than what we see. Berman's work addresses this subject in a manner that pokes fun but never trivializes it. The conundrums he creates out of modest and often surprising materials do not unravel to reveal some essential core, like baseballs stripped of their covers. Instead, they lead the eye into a fractal-like space in which the certainties of sight are rendered both magical and moot.

AFTERWORD

By Andy Grundberg

BIOGRAPHY

Zeke Berman was born in 1951 in New York City. He was graduated from the High School of Music and Art in New York in 1969 and from the Philadelphia College of Art in 1972. He currently lives in New York City and teaches at the School of Visual Arts and Fordham University at Lincoln Center.

SELECTED EXHIBITIONS

INDIVIDUAL EXHIBITIONS

1991 The Friends of Photography, San Francisco

University of Missouri Museum, Kansas City, Missouri

Lieberman & Saul Gallery, New York

1990 Jan Kesner Gallery, Los Angeles

1989 Lieberman & Saul Gallery, New York

Fay Gold Gallery, Atlanta

1988 Edwynn Houk Gallery, Chicago

1987 Cleveland Museum of Art, Cleveland

San Francisco Camerawork, San Francisco

1986 The Art Institute of Chicago, Chicago

1985 Lieberman & Saul Gallery, New York

Light Work Gallery, Syracuse

1984 Museum of Modern Art, Bern, Switzerland

Robert Klein Gallery, Boston

Oggi Domani Gallery, New York

1983 UCLA, White Gallery, Los Angeles

Art Space Gallery, Los Angeles

1982 Blue Sky Gallery, Portland, Oregon

1980 Everson Museum, Syracuse

GROUP EXHIBITIONS

1991 The Museum of Modern Art, New York
Works from the Permanent Collection

Hirshhorn Museum, Washington

The New Orleans Museum of Art, New Orleans
Altered Truths: The Michael Myers/Russell Bright Collection

Cleveland Center for Contemporary Art, Cleveland
Protection & Risk, Photographs Commissioned by the Progressive Corporation

The University of Akron, Akron, Ohio
Photography and Drawing

1990 The Museum of Modern Art, New York
Photography Until Now

Los Angeles County Museum of Art, Los Angeles
Photographs from the Graham Nash Collection

Vrej-Baghoomian Gallery, New York
Grids

1989 The Metropolitan Museum of Art, New York
Invention and Continuity in Contemporary Photography

The National Gallery, Washington
On the Art of Fixing a Shadow, 150 Years of Photography

The National Museum of American Art, Washington
The Photography of Invention

The Museum of Fine Arts, Boston
Capturing an Image: Collecting 150 Years of Photography

1988 International Center of Photography, New York
Fabrications

White Columns Gallery, New York
Inside Out Photography

1987 The Tampa Museum, Tampa, Florida
Directors Choice

The Museum of Fine Arts, Santa Fe, New Mexico
The Poetics of Space

Baltimore Museum of Art, Baltimore
Arrangements for the Camera

1986 Whitney Museum, Stamford, Connecticut
Photo Fictions

Baskerville & Watson Gallery, New York

VITA

1985 The Museum of Modern Art, New York
New Photography

The Brooklyn Museum, Brooklyn
Recent Acquisitions

Rice University, Houston
Interiors

1984 Artists' space, New York
New Galleries of the Lower East Side

Catskill Center for Photography, Woodstock,
New York
Contemporary Still Lifes

1983 Islip Museum, Islip, New York
Wit of Rye

Wright State University, Ohio
American Set-Ups

1982 The Museum of Modern Art, New York
Still Life: Photographs from the Collection

The Metropolitan Museum of Art, New York
Counterparts

Seibu Museum, Tokyo, Japan
*20th Century Photographs from the Museum of
Modern Art*

Grants and Fellowships

1991, 1988, 1987 MacDowell Colony Residency,
Peterborough, New Hampshire

1990 Djerassi Foundation Residency, Woodside,
California

1989 Yaddo Residency, Saratoga Springs, New York

1988 National Endowment for the Arts Fellowship

New York Foundation for the Arts Fellowship

1984 John Simon Guggenheim Memorial Fellowship

1980 Light Work Residency, Syracuse, New York

Creative Arts Public Service Fellowship

Bibliography

Books and Catalogs

Hoy, Anne E. *Fabrications.*
New York: Abbeville Press, 1988.

Smith, Joshua. *The Photography of Invention.*
Washington, D.C.: The National Museum of
American Art, 1989.

Szarkowski, John. *Photography Until Now.*
New York: The Museum of Modern Art, 1990.

Ellis Island: Echoes from a Nation's Past.
New York: Aperture, 1990.

Informed Objects. Riverside: California Museum of
Photography, 1989.

Frames of Reference, Photographic Paths.
Baltimore: University of Maryland, 1989.

Zeke Berman: Photographs.
Essay by Marvin Trachtenberg. New York: Lieberman
& Saul Gallery, 1989. (exhibition catalog).

Reviews and Articles

Goldberg, Vicki. "Still Lifes Fooling Around."
American Photographer (April 1987).

Grundberg, Andy. *The New York Times* (March 31, 1989).

——————. *The New York Times* (September 15,
1985).

Hagen, Charles. "Photography and Drawing," *Aperture*
(fall 1991).

Harrison, Helen. *The New York Times* (October 10,
1985).

Heimerdinger, Debra. "Density, Mass, Gravity." *re:view,*
11:6 (June 1988).

Johnstone, Mark. *Artweek* (December 25, 1982).

Marx, Katherine. "Photography: The State of the Art."
Cliché, 1988.

McKenna, Kristin. *The Los Angeles Times,*
November 30, 1990.

Raedeke, Paul. "Interview with Zeke Berman."
Photo Metro, vol. 9, issue 85, (January 1991).

Westerbeck, Colin. *Artforum* (March 1980).

Wise, Kelly. *The Boston Globe* (May 12, 1985).

The Friends of Photography, founded in
1967 in Carmel, California, is a not-for-profit
membership organization that operates
the Ansel Adams Center in San Francisco.
The programs of The Friends in publica-
tions, exhibitions, education and awards to
photographers are guided by a commit-
ment to photography as a fine art and to the
discussion of photography through critical
inquiry. The publications of The Friends
and the exhibitions at the Ansel Adams
Center are the primary benefits of member-
ship; they emphasize current photographic
practice as well as criticism and the
history of the medium. Membership is open
to everyone. To receive additional information
and a membership brochure, please write
the Membership Director, The Friends of
Photography, Ansel Adams Center,
250 Fourth Street, San Francisco,
California 94103.

Ronald Sterling Egherman,
Executive Director
The Friends of Photography

Staff for Optiks:

Curator: Debra Heimerdinger

Editor: Andy Grundberg

*Graphic design: Linda Hinrichs,
Carol Kramer, Pentagram*

Production: Ken Coburn, Interprint

Printed in Hong Kong